Noël Bourcier

ANDRÉ
KERTÉSZ 55

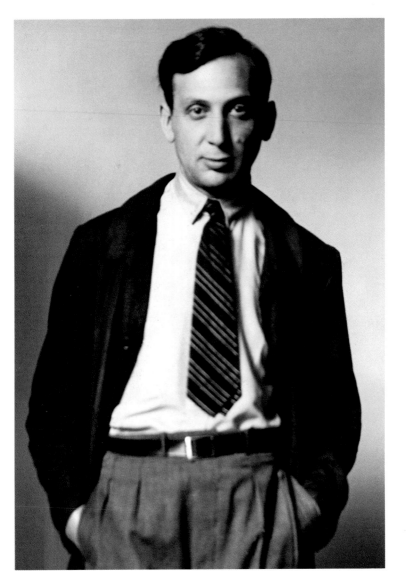

A classic among classics, André Kertész is one of the greatest photographers of the twentieth century. Deeply reserved, he consistently remained true to his beliefs and origins. His work, which received belated international recognition from the 1960s on, always drew on his personal life, without lapsing into autobiography. Though the streets were his familiar territory, he was neither a distant observer nor a committed documentor of history, politics and the great events of the day. His artistic aspirations sent him on a quest for authenticity that led to the invention of an original and innovative visual language. He eschewed the dogmatic positions of schools and movements, letting himself be guided only by his intuition. And while his work allows certain historical comparisons, it cannot be reduced in aesthetic terms to a particular style. Kertész created new forms, and was one of the first modern photographers to understand and exploit the true possibilities of photography. His work moves smoothly, and with great subtlety, between abstraction and Surrealism, Constructivism and humanism.

André Kertész was born into a middle-class family in Budapest on 2 July 1894. He was fifteen years old when his father, Lipót Kertész, died. His mother, Ernesztin Hoffmann (1863–1933), and his uncle, Lipót Hoffmann (1855–1925), took charge of his education (although he was Jewish, he received no religious tuition) and that of his two brothers, Eugenio (1897–late 1970s), and Imre (1890–1957). Imre was soon to make up for his father's absence, working as a stockbroker to support the family. Eugenio (or Jenő) was to become André's favourite model, his athletic, radiant double, before emigrating to Argentina, where he obtained a job as an engineer. André would never lose his deep fondness for him, and Jenő's portrait would take pride of place in his Paris laboratory, like an admonition to remain true to his roots. For the Kertészs felt

themselves to be different from other families: 'We are predestined for something, and sooner or later this destiny will come to pass ... What delights me most is that you have become a photographer ... this way, you will be a happy man,' wrote Jenő to André from Buenos Aires in 1926.

Uninterested in formal education, just as he would later be hostile to dogmatic aesthetic positions, he preferred to play truant, strolling instead in Budapest's public gardens and municipal park. Kertész would retain fond memories of his early years: 'When I was taking photographs in Tiszaszalka, in Esztergom, in Dunaharaszti, in France and in New York, it was the landscape and people of Esztergom who came to life again in each photograph.' His first known photograph dates from 1912. *Boy Sleeping* foreshadows what were to be the essential characteristics of his art: clarity of style, a proclivity for geometric patterns and the primacy of emotion.

Drafted into the Austro-Hungarian army in early 1915, Kertész volunteered for the Russian and Polish fronts. He was a romantic young man who believed that the trials of life would reveal his true identity. He already saw himself as a photographer, and took with him a small Goerz Tessac camera with a 75 mm lens. Eschewing documentation of the war in the epic style, he depicted the daily life of the soldiers, the waiting in the trenches and the long marches. He photographed his own war: that of an insignificant soldier lost among the torments of history. Wounded in his left hand on the Polish front, Kertész was partially paralysed for over a year and contracted typhoid fever. However, he put his convalescence, first in Budapest and later in Esztergom, to good use by continuing to take photographs, including the promising *Underwater Swimmer* (page 25).

After the war, Kertész reluctantly took a job on the Budapest commodity exchange but he could not resign himself to an administrative post. Whenever possible, he escaped to the banks of the Danube and photographed Jenő running, swimming and leaping about. The affection of his family, and close friendships with artists such as Vilmos Aba-Novák, István Szönyi, Imre Czumpf and Gyula Zilzer, most of whom he would later encounter again in Paris, helped mould his sensibility. In 1919, Kertész met his future wife, Erzsébet Salamon (Elisabeth Sali, 1904–77), at that time only fifteen years old. Brought together by their common love of art, they established a rapport and affection that would endure throughout their lives.

Kertész found his favourite subjects in everyday life. Whether photographing Jenő, his mother's hands, or Mária Váci – the daughter of a neighbouring wine grower – as a village Madonna, his frame of reference remained resolutely his own milieu. He had already become what the French poet Paul Dermée would call that 'seeing brother', quoted on the invitation card of his first Paris exhibition in 1927. To observe, to feel, and to convey his experience so as to reveal the truth, were Kertész's abiding principles.

Although Kertész was nostalgic, and cultivated this desire to capture the fleeting moment as the driving force of his creative work, it would be wrong to regard him as a sentimental photographer. For him, taking a photograph involved encapsulating an atmosphere but also solving compositional problems, linking form and content. While the exhibitions of the time displayed so-called 'pictorial-ist' photography, Kertész refused to adapt to these fashionable aesthetics, which, further west, were already on their way out. Nor would he use procedures such as gum bichromate or bromoil to give his prints a misty appearance.

Instead, he sought spontaneity. He was not aiming for recognition as an artist; he used the camera as a tool to reveal something of the human condition.

From the start, Kertész, who described himself as a 'born photographer', seemed to have an intuitive feel for the camera's possibilities. Before the advent of the Leica in 1926, he produced surprisingly natural images and novel compositions, unconsciously becoming a pioneer of modern photography. In September 1925, finding Budapest unable to offer him sufficient cultural and artistic opportunities, he left for Paris. Filled with hope and determination, he temporarily left behind Elisabeth, to whom he was now engaged, until he could find a steady job there.

Kertész was not the only Hungarian artist to make this choice. The dismantling of the Austro-Hungarian Empire had radically changed the borders of Europe, and Ergy Landau, François Kollar, Emeric Feher, Brassaï, Izis, Germaine Krull and Robert Capa all arrived in Paris at around this time. 'The City of Light' became the point of convergence of what was to become the international avant-garde, with others such as Berenice Abbott and Man Ray emigrating there from the United States. Thanks to this cosmopolitanism, exchanges among the different art forms proliferated.

Arriving in Paris, Kertész was to benefit from this revolutionary creative ferment. He spoke not a word of French, but when Gyula Zilzer introduced him to the writer Michel Seuphor (friend and interpreter to Piet Mondrian), whom he would repeatedly photograph and who would take him to the studios of Fernand Léger, André Lhote, Ossip Zadkine, Jean Lurçat, Piet Mondrian, Alexander Calder and Tsugouharu Foujita, they were able to exchange a few words in

German. In Montparnasse he was absorbed into the Hungarian community, notable among whom were the sculptors István Beöthy and József Czáky, the graphic artist Gyula Zilzer, painter Lajos Tihanyi and textile designer Eva Révai. The Café du Dôme was the meeting point for these bohemians among the Montparnasse elite.

Kertész was to play a decisive role in the blossoming talent of his compatriot Brassaï (Gyula Halász), who had never before touched a camera. Initially, he borrowed Kertész's, asking his advice on how to photograph night-time scenes. A quarrel over a publishing project, however, which Kertész rejected and Brassaï accepted, put an end to their mutual rapport. The resulting rancour proved lasting, and was kept alive over the years by a mixture of reciprocal admiration and jealousy. Brassaï, worldly and ambitious, was to succeed in scaling the heights of the art world, thanks in particular to his friendship with Pablo Picasso. Years later, he recognized the role that Kertész had played in his decision to take up photography, describing him as 'one of the greatest photographers of our time'. Though Kertész lacked the temperament of a leader, his calm self-confidence was sufficiently persuasive to encourage many evolving artists to follow in his footsteps. A flourishing press helped fulfil their expectations.

Kertész rediscovered the pleasures of walking the streets, strolling along the banks of the Seine and wandering in the parks. Like any tourist, he could be found at the Eiffel Tower, the Place de la Concorde, Notre Dame, Montmartre and the Champs Elysées. But he was not interested in trite, stereotypical images. It was the incidental and the accidental that attracted him: a signboard for a cabaret, the shadow cast by a chair, an advertisement for Dubonnet, bricks on a building site. Caught up in his work and bohemian life, Kertész abandoned

Elisabeth, whose correspondence seemed to have ceased. On 2 October 1928, he married Rószi Klein (1900–70), whom he had introduced to photography and was known under the pseudonym Rogi André (from Kertész's first name). Two years later, however, the couple separated, and were divorced in 1932. During a trip to Hungary, Kertész discovered that Elisabeth had not stopped writing to him, but that her letters had somehow failed to reach him. Rogi had presumably intercepted them in order to protect their relationship. Elisabeth visited Kertész in Paris in 1931 and moved in with him permanently in 1933. They married on 17 June. She soon found a job in Helena Rubinstein's cosmetics firm. Kertész never again referred to Rogi André and obliterated all traces of his first marriage.

In 1927 the avant-garde gallery Au Sacre du Printemps offered Kertész his first exhibition. The prints, which had no borders, were pasted to drawing paper and pinned to the wall. The following year, Kertész, together with Berenice Abbott, Laure Albin-Guillot, George Hoyningen-Huene, Germanie Krull, Man Ray, Nadar and Eugène Atget, took part in the First Independent Exhibition of Photography, known as the 'Salon de L'Escalier'. At an international level, Kertész was also represented in the exhibition 'Film und Foto', held in Stuttgart in 1929. This show constituted a meeting point for the avant-garde of the day, asserting photography's unique character in relation to the other arts. Reference to classical models from painting was no longer considered necessary, and technique was now deemed the door to progress. Photography, uniting optics and chemistry, became a symbol of this quest for modernity.

Kertész began using a Leica in 1928, soon after it came on the market in Germany. Light, easy to handle and equipped with a viewfinder, the Leica used film on rolls. It opened up new possibilities for the photographers of the day,

enabling them to work in weaker light, to freeze movement more easily, to take several pictures in rapid succession and to be more mobile. By raising the transience of the moment to its highest intensity, *Meudon* (page 61) opened the way to photojournalism.

The 'surreality' of some of the photographs of this period lies in the magnification of moments of life, whose fragility evoke an irrepressible pang of anguish. The critic Susan Sontag described this in 1979 (in *On Photography*) as a 'wing of pathos'. *The Fork* (page 63), and *Mondrian's Pipe and Glasses* (page 47) not only constitute admirable formal compositions, but also elevate seemingly trivial details into meditative poems. It is perhaps in this quality that the central core of Kertész's art lies. When he turns his focus from objects to people, he reveals, behind a face or an expression, universal feelings. Described by the critic Jean-Claude Lemagny as the 'master of moderation', he aimed to reflect emotion truthfully. Whether photographing a sleeping tramp or the shadows of the Eiffel Tower, there was no hierarchy in his choice of subjects.

At the same time, this poet of the ephemeral was an inventor capable of providing photography with both a new vocabulary and novel stylistic devices. In *Satiric Dancer* (page 39) he made use of the visual rhyme between Magda Förstner's contorted body and István Beöthy's sculpture. This manner of seeing, which has now become classically photographic, would later be repeatedly applied by Henri Cartier-Bresson.

The series 'Distortions' (pages 87 and 89) holds a unique place in Kertész's oeuvre. Never before had he devoted himself to a theme with such accomplishment. Its originality lay in the manner in which it combined the traditional genre of the

nude with a resolutely modern procedure – the series – and interpretation – the hall-of-mirror-style contortion of form. However, the strangeness of the 'Distortions' does not stem from an attempt to be especially experimental or novel. Unlike Man Ray, Raoul Ubac or the Bauhaus photographers, whose central concern was experimentation, Kertész was not driven by a desire to innovate. Nor did he aim for Surrealism; it came naturally to him. In this series, Kertész used his optical deformations in the service of lyricism. In doing so, he made a major contribution, not just to the history of photography, but to that of contemporary art in general.

It would be true to say that just as Kertész adopted Paris, it adopted him. His originality was soon recognized, and as he continued to blossom artistically, he found recognition in press circles. Numerous magazines wanted to publish his work. In France these included *L'Art vivant*, *Art et Médecine*, *L'Image*, *Regards*, *Vogue*, *Plaisir de France*, *Paris Magazine*, *L'Illustration*; in Germany, *Frankfurter Illustrierte*, *Neue Jugend*, *Münchner Illustrierte Presse*, *Uhu*, *Berliner Illustrierte Zeitung*; in England, *The Sphere* and *The Sketch*. From 1928 to 1935 Kertész was one of the main contributors to the magazine *Vu*, edited by Lucien Vogel. Managing editors such as Stefan Lorant (*Münchner Illustrierte Presse*, *Lilliput*) and Charles Peignot (*Arts et Métiers graphiques*), editors and artistic directors such as Carlo Rim and Alexander Libermann (*Vu*) were talented disseminators of the work of a whole generation of photographers: François Kollar, Brassaï, Germaine Krull, René Zuber, Roger Schall, Man Ray, Nora Dumas and Emmanuel Sougez, to name but a few.

Nineteen thirty-four saw the publication of *Paris vu par André Kertész* (*Paris as seen by André Kertész*), with text by Pierre MacOrlan. This book marks the

conclusion of his time in Paris, for in 1936, when Kertész was without doubt at the height of his powers, Erney Prince at the Keystone agency offered him a contract, which required that he move to New York. He went there intending to stay a year and remained in the United States until his death. However, he would always regret this choice. For no matter where he was, Kertész never felt entirely at ease. In Hungary, he was drawn to Paris. Settled in Paris, and despite his success, he continually complained about his circumstances, as can be seen from his family correspondence. When, from the 1960s onwards, he had achieved fame in the United States and throughout the world, he felt that it had come too late and was to reproach the Americans for having exploited him.

As Surrealism and Constructivism ran out of steam in Europe, New York was supplanting Paris and Berlin as the centre of artistic creation. Numerous artists and intellectuals yielded to the lure of this megalopolis, which was spared the political tensions of the pre-war period. The decision to move to the America had not been an easy one for Kertész. Would the Americans offer him the possibility of pursuing his work with the same degree of freedom? In a state of uncertainty, Kertész sought the view of his older brother, who had remained in Budapest. In a letter of 17 April 1936, Jenő predicted, 'You'll end up with them in your pocket.' With mingled apprehension and confidence, Kertész decided to accept the offer. Professional considerations were the only ones that he would recall. Although the atmosphere in Germany was deteriorating badly (in 1933 Hitler had declared the Nazis the sole legal party and had launched its programme of racial purification), the fact that Kertész was Jewish does not appear to have had the slightest influence on his departure. He and Elisabeth arrived in New York in October 1936. His work with Keystone lasted less than a year, when he resumed his status of freelance photographer. Now there was no longer any question of returning.

In 1937 the PM Gallery offered Kertész his first one-man exhibition in the United States. Classified as an 'enemy alien' during the war by virtue of his nationality, however, he was denied access to the means of publicizing his work. After obtaining American nationality in 1944, he published *Day of Paris*, an idea conceived by Alexey Brodovitch, the charismatic artistic director of *Harper's Bazaar*. But commissions were few and far between. An exhibition devoted to his work at the Art Institute of Chicago in 1946 was not enough to establish Kertész as a major figure in American photography, and he understood his second adopted country no better than it understood him.

Confronted with the monumental city, Kertész's vision became sharper, without losing its tender tone. But his name did not appear alongside those of Berenice Abbott, Lisette Model, Louis Faurer and Ted Croner, the street photographers of the New York School. While the hard edge of New York life impelled Weegee and William Klein to a redeeming confrontation, and Robert Frank to productive flight, it led Kertész to withdraw into himself. One reason for his difficulty in fitting into the American production system lay in his inability to submit to the demands of any commission that was too directive. For him, studio photography, posed subjects, or directing a team of assistants, represented an insurmountable effort. Professionally isolated, refusing to adapt to the demands of the American press, Kertész balanced like a tightrope walker on his ephemeral and subtle art. When he wanted to publish his street photographs in *Life*, he was told that they 'spoke too much'.

After contributing occasionally to *Harper's Bazaar*, *Vogue*, *Town and Country*, *The American House*, *Collier's*, *Coronet* and *Look*, in 1949 Kertész signed an exclusive contract with publishers Condé Nast. He photographed up to 100

subjects a year for *House and Garden*, whose artistic director was Alexander Libermann. Kertész did not regard any of this work as worthy of inclusion in his personal oeuvre, however, claiming, 'They are just lifeless documents, nothing more.' Whether due to financial pressure, or for other reasons, he seems to have renounced all creativity in his professional work at this time. Regarding this, Brassaï made the sad observation that 'Kertész couldn't find himself any more, and in the end perhaps he even gave up looking.' In 1962, weary, weakened by a prostate operation, feeling he was being made poor use of, he broke his contract with Condé Nast. He was now 68 years old. His commercial career in America ended as it had begun, in sadness and incomprehension.

In recalling this period, Kertész often spoke of the lack of close contact with other artists. In Paris, he had created his masterpieces in Mondrian's home or at the Hôtel des Terrasses. In New York, he officiated at the Saks stores or at Winthrop Rockefeller's home. The surroundings had changed; he had remained the same. Those who knew him in his later years recall his fatalism and a certain inclination towards melancholy. Isolated in New York, eternally rootless, without contact with other artists, nothing really stimulated him. When he left France in 1936, Kertész had left behind the negatives from his Hungarian and French periods so that others could 'exploit them commercially' on his behalf. He did not attempt to reclaim them until the occasion of his exhibition in the National Library, Paris (1963), when he visited Paris. Alerted by an article in the newspaper *Le Monde*, Jacqueline Paouillac, to whom Kertész had entrusted them, contacted him and told him that his archives were waiting for him. For over thirty years, Kertész had been separated from the most important part of his work. Deprived of these archives, like someone who has lost his memory, all those years he had lived in one place without, as it were, ever unpacking his

bags. It could well be that had he had his past work with him, it might have given him the strength to follow a different course. Recognition of his achievement would certainly have come more quickly. The rediscovery of his negatives was the beginning of his resurrection, both on a personal level and within the international photographic community. From then on, he wanted to show that his best work did not lie behind him. Enthusiastically, he took up his camera and relaunched his photographic activity around three main themes: geometric composition, still life and colour, making especial use of the Polaroid camera.

Abandoning the street due to his physical condition, he withdrew into his own private world. From the window of his apartment at 2 Fifth Avenue, overlooking Washington Square, Kertész never tired of observing the spectacle of the passers-by. Variations on a single theme, to the point of obsession, now became a feature of his approach. Angular roofs, crooked chimneys, anonymous windows and terraces crowded with strangers were his leitmotifs. He made up for his limited mobility by using a zoom lens and composed urban landscapes in which geometry took precedence over people.

The more his own physical presence dwindled, the more demanding his retina became. He was fascinated by the quest for balance and formal perfection. With meticulous care, he arranged glass, wooden and bronze objects near his window and applied himself to recording the minute variations of light on their surface. His increasingly introspective mind focused on these details. Between 1979 and 1981 he used an instant camera. A book of these Polaroid pictures, conceived as a token of his love for Elisabeth, who had died of cancer in 1977, appeared under the title *From my Window* (1981). It was more than a brilliant exercise in style: it demonstrated, with great economy of means, Kertész's absolute mastery of light.

After his 1964 exhibition at the Metropolitan Museum of Art in New York, many other cities paid homage to him (Tokyo, Stockholm, Budapest, London, Helsinki, Jerusalem). In 1975 Kertész was guest of honour at the Sixth International Festival of Photography in Arles, and his work was exhibited at the Agathe Gaillard Gallery, Paris, and in 1977, at the Georges Pompidou Centre, Paris, which had just opened its doors. From the 1970s onwards, there was a stream of publications of his work: *Sixty Years of Photography, 1912–1972* (1972), *J'aime Paris* (1974), *Washington Square* (1975), *Of New York* (1976), *Distortions* (1976), *Americana – Birds – Landscapes – Portraits* (1979), *A Lifetime of Photography* (1982), *Hungarian Memories* (1982), *André Kertész, the Manchester Collection* (1984), *Of Paris and New York* (1985). He was also the subject of several films, notably for British television. At the suggestion of film-maker Teri Wehn-Damish, in 1984 Kertész produced a new series of 'Distortions'. During the 1980s, sales of prints saw a new upswing, reaching a peak at Christie's in 1997, when *Mondrian's Pipe and Glasses* (1926) fetched $376,500, perhaps the ultimate sign of recognition for someone who had always felt undervalued.

On 28 September 1985, Kertész died in his New York home, leaving an extensive body of work (100,000 negatives), not all of whose treasures have yet been revealed. The strength of this oeuvre lies in the way in which it anticipated or intersected the avant-garde movements of the day, while never abandoning a classic purity. To Kertész, this authenticity, which captured his subject's innnermost being, was his most precious possession. It was perhaps Henri Cartier-Bresson who paid him the finest tribute when he said, 'Each time André Kertész's shutter clicks, I feel his heart beating.'

Boy Sleeping, Budapest, 1912. Kertész consistently identified this as his first photograph, made when he was eighteen years old. It sums up the essence of his art: exploration of the intimate domain, a proclivity for the geometric (seen in the cruciform composition) and a modern subject. In 1912 it required much daring and intuition to perceive a worthy photographic subject in this mundane scene. The family grocer's shop provided the background.

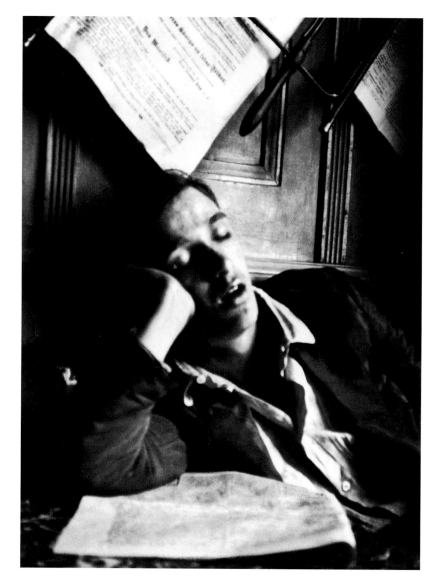

Tender Touch, Poland, 1915. At the beginning of 1915, Kertész volunteered for the Austro-Hungarian army as an officer cadet in the 26th Infantry Regiment. He became a trainee in the school for officers in Görz, Austria. In pessimistic mood, he expected to end his life on the battlefield. As his sole consolation, he took with him a small camera using 4.5 x 6 cm/1.75 x 2.4 inch glass plates. During a stop in Bilinski, he photographed one of his comrades putting on the charm for a peasant girl. The result was a perfect reportage snapshot, prefiguring the 'Leica vision' of photojournalism which would become widespread in the 1930s.

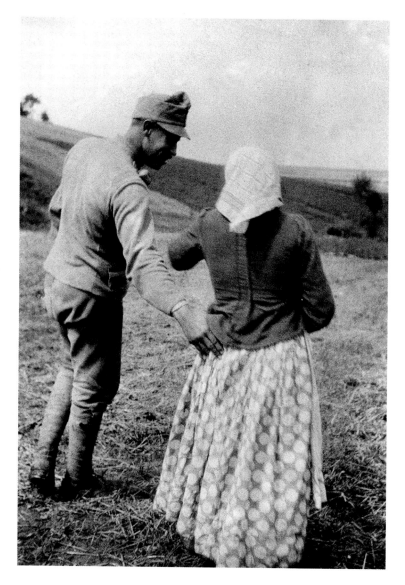

Esztergom, Hungary, 1916. Having gone off to war to find a meaning to his life, Kertész recognized himself to be a resolutely peace-loving, romantic young man. Coming under fire on the Polish front, he escaped with a seriously wounded hand. His friends at the time were Hungarians, Albanians and gypsies. At Esztergom, he spent his convalescence photographing his comrades in misfortune, in this case, the gypsy Lajos Mihalik. His aim, which he was unable to realize, was to publish these photographs in the form of books or postcards to raise funds for the Red Cross.

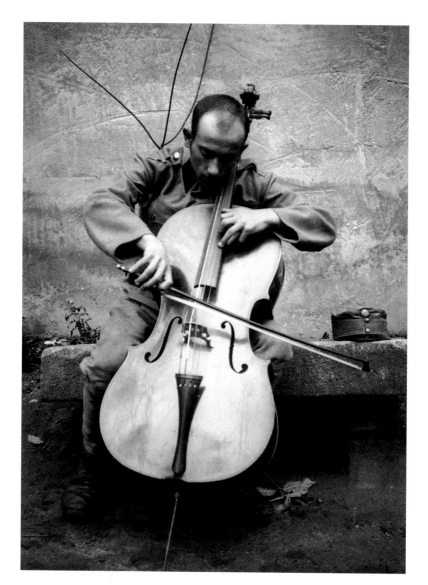

Esztergom, Hungary, 1917. Kertész's earliest years were spent in the village of Szigetbecse. He later commented on how greatly this period in the country-side contributed to forming his sensibility. Although his childhood was not unhappy, he was a poor pupil with a wanderer's temperament, and until he became a photographer, he was haunted by a deep feeling of boredom and use-lessness. Consequently, the tiniest moments of happiness assumed the greatest importance for him. This photograph achieves a universal quality by capturing such a moment, which is immediately recognizable to all.

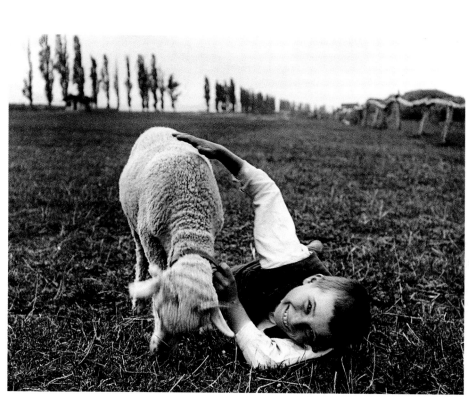

Underwater Swimmer, Esztergom, Hungary, 1917. Convalescing in Esztergom, Kertész underwent massage and physiotherapy sessions in the swimming pool. 'The water of the pool shone with a magnificent blue. We were sitting around it with the others, when suddenly I saw the reflections and the little movements on the surface.' Taken using a 9 x 12 cm/3.5 x 4.75 in. glass plate, the original composition was larger, but was trimmed down around the diver and slightly tilted to accentuate its dynamic quality. During the years 1920–30, the Bauhaus was to popularize the aesthetics of reflections (mirrors, glass balls, the chrome detailing on cars, etc.), which became a leitmotif of the modern movement.

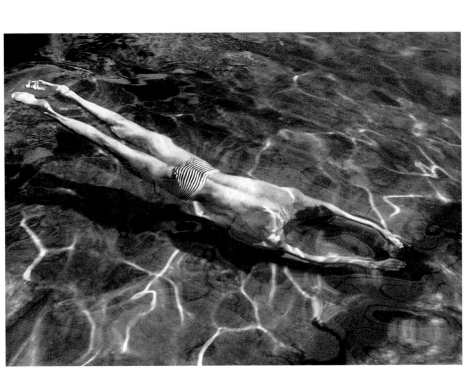

Dunaharaszti, Hungary, 1919. In 1919, although the armistice had been signed in the West, Hungary's fate had not yet been settled. Kertész was living in the country when the Romanians occupied Budapest on 3 August. His younger brother Jenő was the model for this photograph, taken on 14 September. Throughout his career, Kertész made systematic use of cropping to accentuate an effect, balance a composition, or eliminate an extraneous detail. Here, he has also inverted the image, as the Surrealists, Man Ray in particular, would do later.

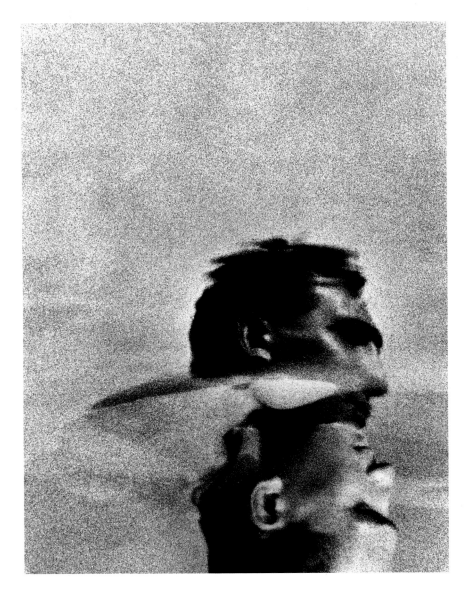

My Brother as a Scherzo, Hungary, 1919. This photograph shows the element of staging and fiction to which Kertész might resort in order to give visual form to an idea. One day, he asked his brother, with whom he spent his free time running and swimming, to express a scherzo – a lively, cheerful piece of music. In Italian, the word means 'banter' – or good-natured jesting, which sums up the spirit of this work.

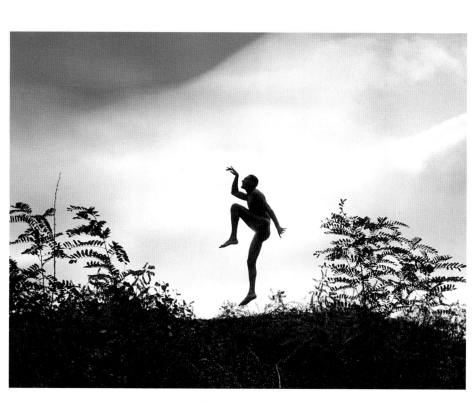

The Circus, Budapest, 1920. Kertész often photographed people who were in the act of looking, rather than focusing on what they were looking at. This photograph, ironically entitled *The Circus*, frustrates our voyeuristic curiosity in order to show us the importance of looking. The simplicity of the composition saves the image from being merely an amusing vignette, however, endowing it with value as a metaphor for the photographer's abiding question: what is truly worth looking at?

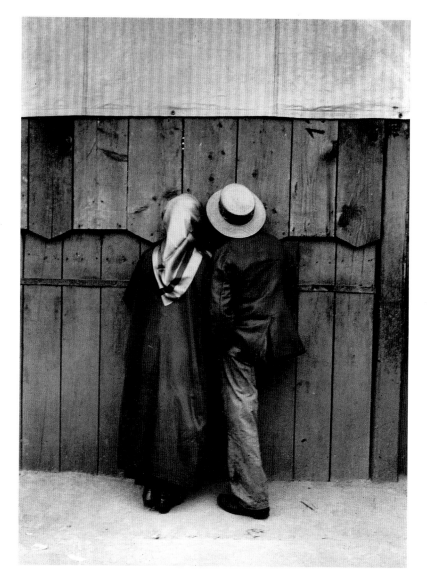

Elisabeth, Dunaharaszti, Hungary, 1920. In 1919, Kertész met Elisabeth at the Budapest Exchange and Clearing Bank, where she was taking a course. She was also studying drawing with Álmos Jaschick, and learning dancing. Only fifteen, she was ten years younger than Kertész. Like him, she came from a middle-class family – her mother ran a hotel-cum-boarding house in Budapest – and had lost her father, a railway employee, at a very early age. Just before Kertész left for Paris, the young couple became engaged.

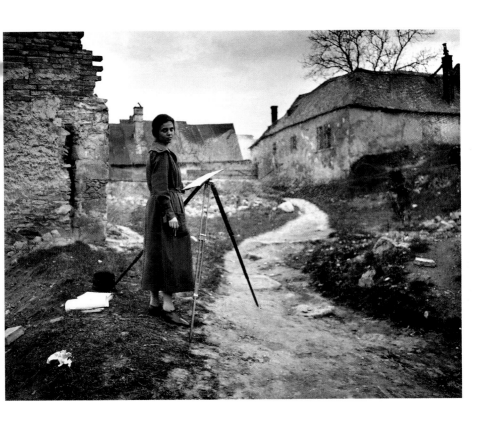

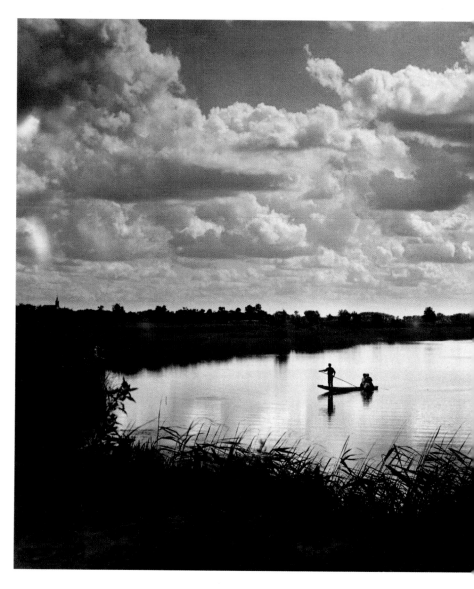

(previous page) Dunaharaszti, Hungary, 1920. This photograph was taken on 30 May, a few days before the Treaty of Trianon deprived Hungary of two-thirds of its territory. Kertész was all too aware of the climate of terror that had reigned in Budapest for the last two years. Firmly left-wing, he hoped above all that his country would guarantee individual liberties. In this photograph, he pretended to ignore the conventions of academic photography — centred subject, horizon halfway up the picture, overcast sky — only to turn them to his advantage. In this way, at the price of some manipulation of the print, he transformed what might have been an utterly banal landscape into a mythic evocation of a country.

Jenő and Imre, Hungary, 1923. Here, Kertész's two brothers are brought together in a symbolic scene. Jenő (left) was twenty-three years old, André twenty-nine, and Imre (right) thirty-three. Their mother, Ernesztin, who had wanted the family to stay together for as long as possible, understood that she could no longer hold her sons back. André left for Paris in September 1925, with his mother's blessing. The following year, Jenő emigrated to Argentina. Imre was to remain in Budapest all his life.

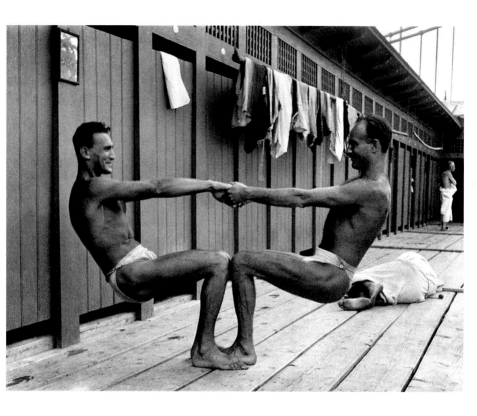

Satiric Dancer, Paris, 1926. The cabaret dancer Magda Förstner, visiting the sculptor István Beöthy, poses in her stage costume. Kertész took only three photographs: two on the sofa (in the other one, Magda is sitting) and one standing in the entrance. When he asked the dancer to think of Beöthy's sculpture, she twisted herself into a harmonious contortion. The downward perspective and wide angle accentuate the dynamic of a composition that is all angles. The mimicry of the forms, which one might call visual rhyme, was to become a characteristically photographic method, used especially by Henri Cartier-Bresson, who made it a major feature of his style.

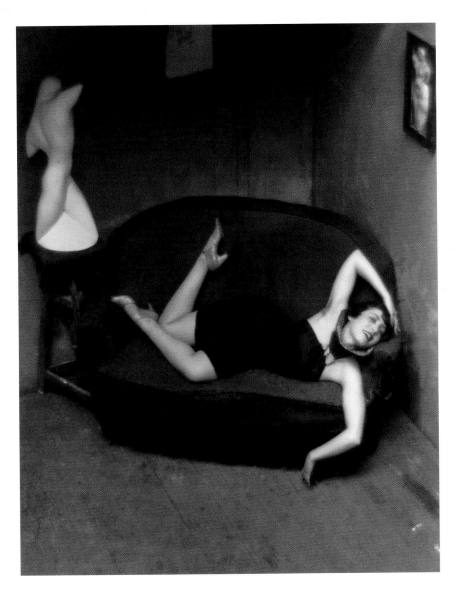

Paul Arma's Hands, Paris, 1926–28. Imre Weisshaus, alias Paul Arma, who composed for and played the piano, had studied with Béla Bartók in Budapest. A version of this photograph appeared on the invitation to his concert at the Salon of Ultra Modern Art. An unconventional portrait, its complex composition aims to render the spirit of the forms independently of the sitter's psychology.

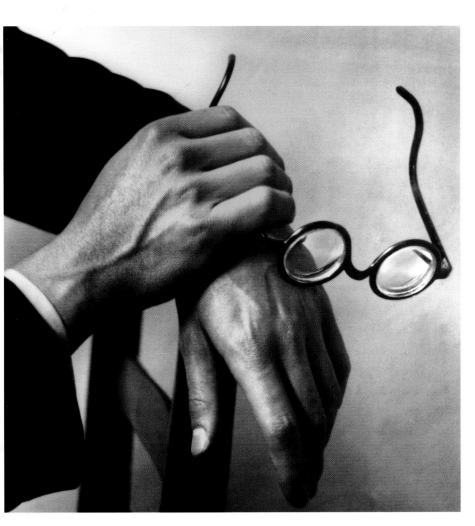

Lajos Tihanyi, Paris, 1926. In the close-knit Hungarian community living in Paris at this time, Tihanyi was the best-known artist apart from József Czáky. He was an abstract painter, whose style was a lively fusion of Cubism and Expressionism. He had links with modern Hungarian movements such as Ma and the Group of Eight. Tihanyi was probably Kertész's best friend in Paris. Their relationship was based on their artistic sympathies (they were both fascinated by the geometry of the Paris rooftops) and a silent mutual understanding – for Tihanyi was deaf and mute.

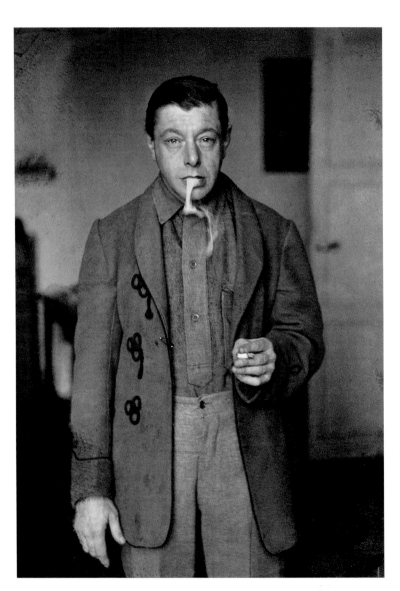

Chez Mondrian, Paris, 1926. The strict partition of space establishes a hierarchy for interpreting the elements of the picture, whose keynote is the vase. The photograph harmonizes the most varied and contradictory formal processes: flatness/Euclidean perspective, clarity/blurring, light/dark. The flower, which looks so alive, was in fact made of wood Along with *Steerage* by Alfred Stieglitz, this photograph became an emblem of modern photography. Kertész resolves the conflicting tendencies within photography, of realism (documentary verisimilitude) versus pure formal language (geometric, two-dimensional composition in black and white).

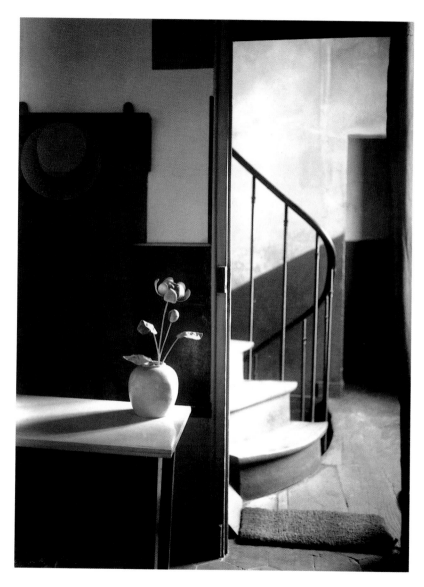

Mondrian's Pipe and Glasses, Paris, 1926. First shown in 1927 at the Au Sacre du Printemps gallery, this photograph synthesizes the modernist ideas promoted especially by *L'Esprit nouveau* (*The New Spirit*, 1920–25). This journal, founded by the poet Paul Dermée, architect Le Corbusier and painter Amédée Ozenfant, promoted new forms of expression, which aimed to express the 'lyrical beauty' of the world of objects. Through his instinctive ability to integrate refined, abstract forms, Kertész captures the spirit of Mondrian's paintings.

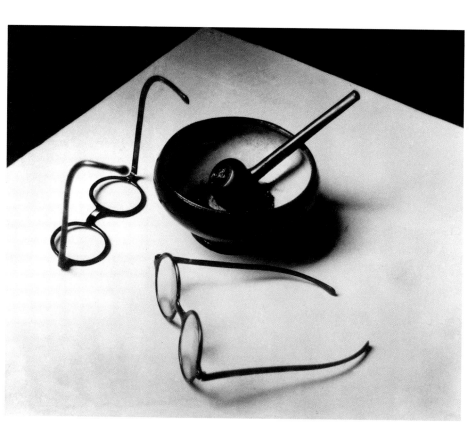

Rue des Vertus, Paris, 1926. This photograph was originally published under the caption 'Bastille, rue de Lappe' in the journal *Art et Médecine* in October 1931, as an illustration for an article by Francis Carco. From 1914 on, Kertész had been interested in night-time photography, using exposures lasting several minutes to capture the immobilized silhouette of his brother Jenő in the streets of Budapest. While for Brassaï, nightfall signalled the emergence of Paris lowlife, for Kertész the city became a theatre of inner emotions, a place both of hope and loneliness.

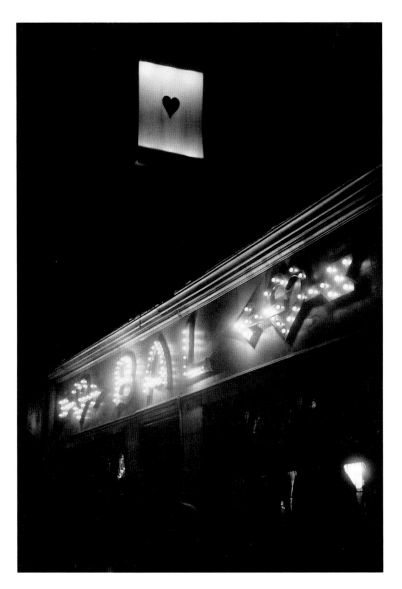

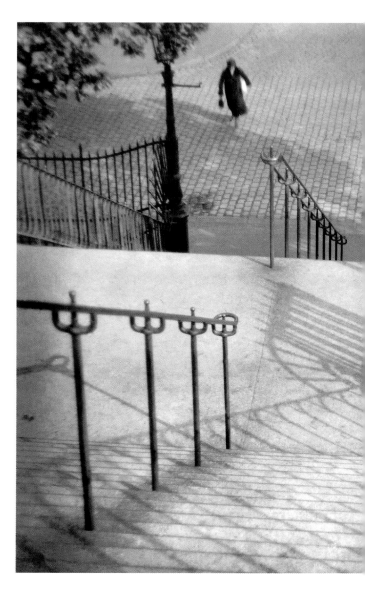

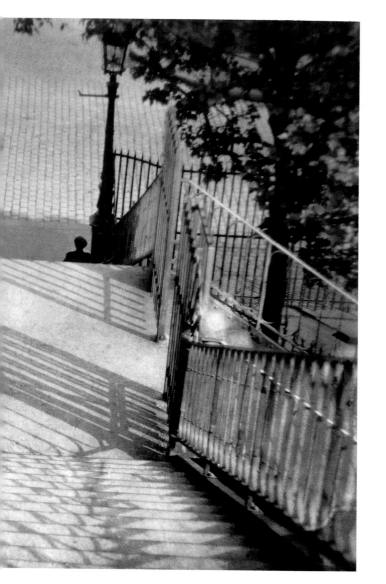

(previous page) **Montmartre, Paris, c.1926.** In the introduction to his book *J'aime Paris* (*I Love Paris*, 1974), Kertész wrote 'I write with light, and the light of Paris is my good friend.' Unlike László Moholy-Nagy, Raoul Hausmann, or Paul Strand, Kertész did not push his use of light to the limits of abstraction. He rejected such devices as solarization, photomontage or photograms, preferring to remain on the side of tangible experience. For him, a composition that was purely formal would have been devoid of interest.

Jolivet Square, Paris, 1926–27. This view was taken from the window of a small hotel in the rue de Maine. The use of a wide-angle lens enabled Kertész to open out the foreground space and accelerate the lines converging on the vanishing point. The street lamp is placed precisely in the centre of the picture in order to emphasize the radiance of the light emanating from it. But the view is also marked out by secondary light sources. Positioned out of sight to left and right, they throw shadows in different directions, complicating interpretation and suggesting a multiplicity of viewpoints.

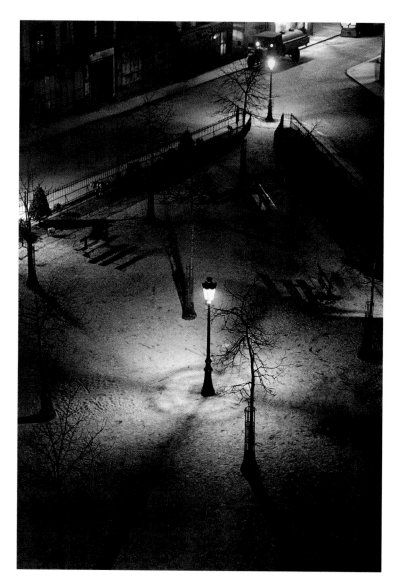

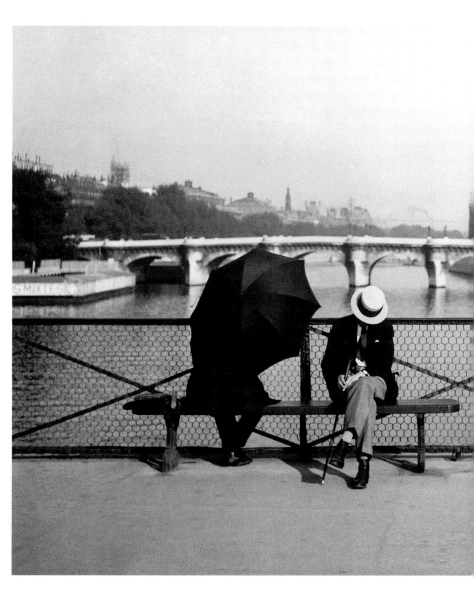

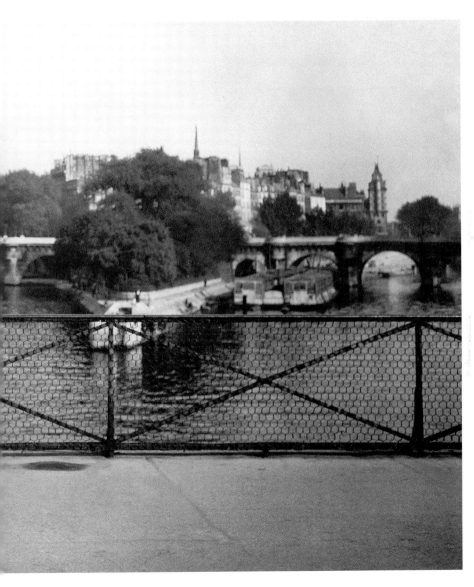

(previous page) Pont des Arts, Paris, 1927. Providing a unique view of the centre of Paris, the Pont des Arts has always been a Mecca for photographers. On one side of the Seine is the Louvre, on the other, the Académie française. In the background, the Pont Neuf, the Île de la Cité and the Vert-Galant public gardens can be discerned. The man beneath the straw hat is Michel Seuphor, editor of the journal *Het Overzich* and, together with Paul Dermée, of *L'Esprit nouveau* (*The New Spirit*, 1920). Seuphor was a great supporter of Kertész during his first two years in Paris. In particular, he introduced him to Mondrian, whom he was enthusiastically promoting. Kertész took several photographs relating to the two men, in the most famous of which, *Chez Mondrian*, Seuphor's role is evoked with gentle irony by the presence of his raincoat and straw hat.

A Poem by Ady, Paris, 1927–28. Though little is known of Kertész's literary tastes, it is certain that he valued the writings of the Hungarian poet Endre Ady (1877–1919). In 1933–4, accompanied by the writer Györay Bölöni, Kertész toured Ady's Parisian haunts. At around this time, an illustrated biography, *Az Igazi Ady* (*The Real Ady*), had been published by Atelier de Paris. Ady, who founded the review *Nyugat* (*The West*) and was strongly influenced by Friedrich Nietzsche, Henri Bergson and by French poetry and Symbolism, reflected the aspirations of the proletariat and recommended looking to the West for models.

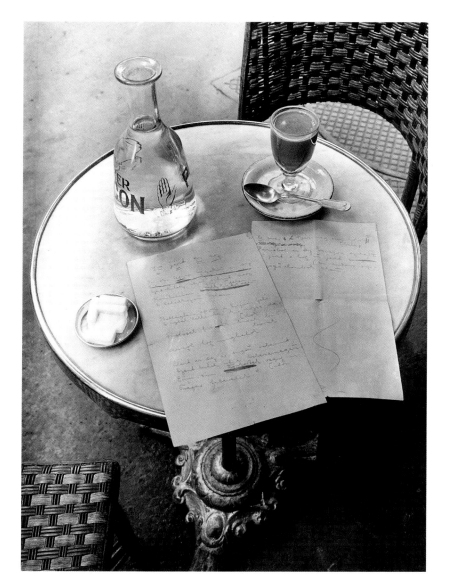

Café du Dôme, Paris, 1928. This photograph was published in the weekly journal *Vu* to illustrate an article on classified ads. It is an example of the artistry with which Kertész could transcend a seemingly mundane assignment. Without the imposing presence of the coal stove, the scene would simply have shown an elegant Parisian woman sitting at a café table. By establishing a disproportion of scale, however, Kertész confines the frail outline of the woman to a corner of the picture, accentuating the distance separating the public from the personal domain.

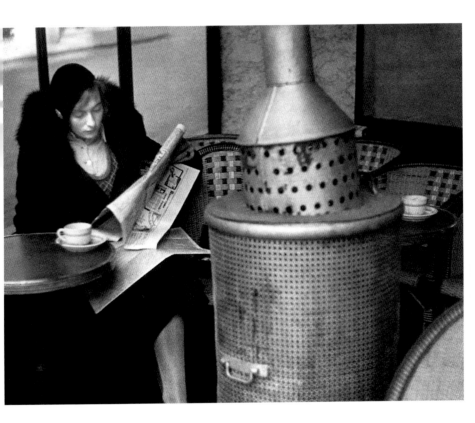

Meudon, France, 1928. Kertész used a Leica to produce this 'miraculous' snapshot. This camera first appeared in Germany in the 1920s. Kertész began using one in 1928, three years prior to Henri Cartier-Bresson. Light and easy to handle, it used film on rolls, and was to become the favourite camera of photojournalists. A vision of movement and speed, capturing people walking in the street and the engine powering over the viaduct, this photograph is an example of what the leader of the Surrealists, André Breton, described as 'opportune magic'. It is thought that the man in the foreground may be the German painter Willi Baumeister, and the parcel he is holding the stretcher of a canvas. Kertész had known him since 1926, when he photographed him in the company of Mondrian and Seuphor.

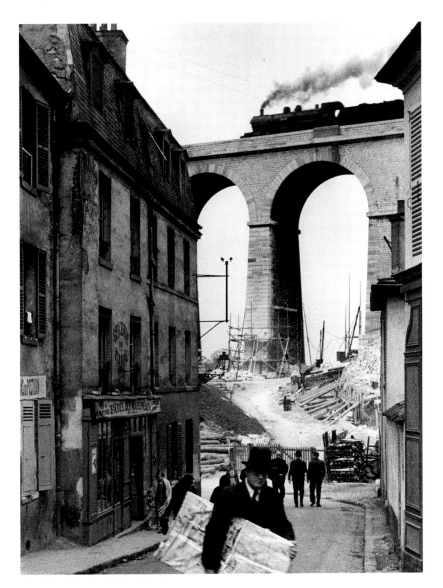

The Fork, Paris, 1928. This photograph was shown at the 'Salon de l'Escalier' (Paris, 1928) and at 'Film und Foto' (Stuttgart, 1929) and was used in an advertisement for the silversmiths Bruckman-Bestecke. The purity of the composition matches the function of the object – the fork is not depicted merely as a formally beautiful object, but also retains its qualities as a utensil. With this vivid description of the spirit of an object, Kertész fulfilled an important artistic goal.

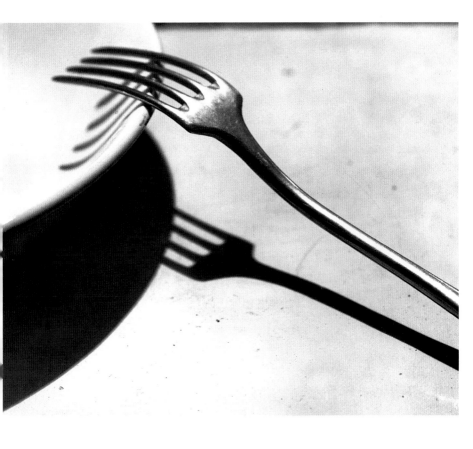

Ballets Ida Rubinstein, Paris, 1928. Kertész was fond of the popular acts appearing at Bobino, a variety theatre in Montparnasse, such as the mime Pomiès or Clayton Bates – a dancer with a wooden leg. Occasionally, he was asked to photograph classical ballet, in this case the dancers of the Ida Rubinstein company, which visited Paris in 1928 and 1929. The report was published in the 28 November 1928 issue of *Vu*. Kertész also photographed the Russian dancer and choreographer Bronislava Nijinska, then under contract to the company.

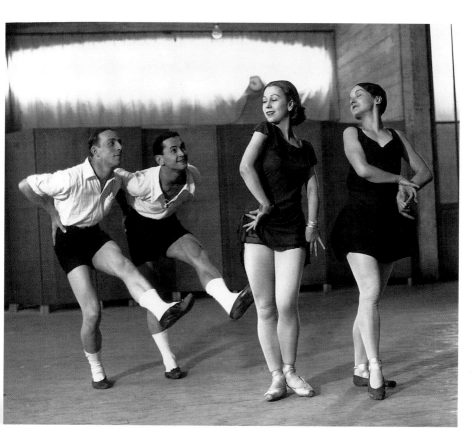

Calder, Paris, 1928–29. The sculptor Alexander Calder arrived in Paris in 1926 aged twenty-eight. The following year, he presented his miniature 'Circus' at the Salon des Humoristes. The performers in this unusual troupe – dogs, lions, lion tamer, tightrope walker – were made of wire and salvaged materials. Calder's studio became a cosmopolitan meeting place for the Parisian elite, from the clown and circus manager Paul Fratellini, to artists and intellectuals of every persuasion. Kertész attended some of these parties, at which the drink flowed freely and Calder entertained his guests with his poetic antics.

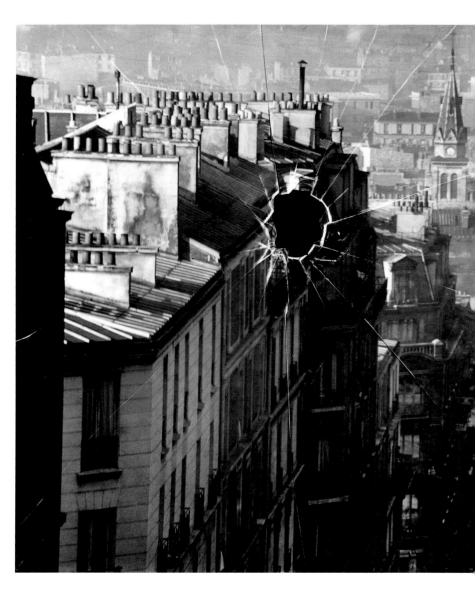

(previous page) Broken Plate, Paris, 1929. This picture was the result of an accident. When, in 1963, Kertész regained possession of his negatives, which he had left behind in France when he moved to New York, he discovered that many of the glass plates were broken. He resigned himself to throwing them away, except for this one, which was fortuitously transformed by the breakage. The negative had originally been taken in order to test the optical quality of a new lens. The work could have been the starting-point for a fresh approach, but Kertész was not one for experiments.

Pavement, Paris, 1929. This photograph's originality lies in its modernist approach to a mundane subject, which links poetic realism and Constructivism. For the latter avant-garde movement, true modernity was to be found in subjects such as architecture (Bauhaus, Le Corbusier), shipbuilding (the steamship *Normandie*, Marseilles's transporter bridge) and the automobile industry.

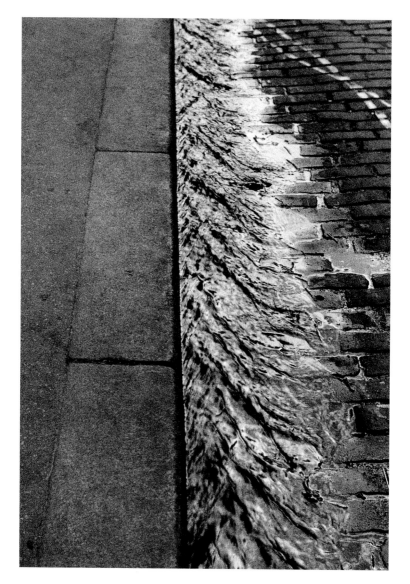

By the Seine, Paris, 1930. In Hungary, Kertész had photographed peasants and gypsies. In Paris, he turned his gaze on down-and-outs or workers out on the town. Though the city had its share of social injustices, for Kertész it was a place where solidarity was still able to overcome poverty. He saw living as a beggar, sleeping under bridges or beneath a tree, washing with water from the Seine, not so much as a sign of dereliction, but as a genuine way of life, though he edited out the less attractive aspects of such an existence. After the war, this sort of 'humanism, French style' found ardent defenders in Robert Doisneau, Édouard Boubat and Willy Ronis.

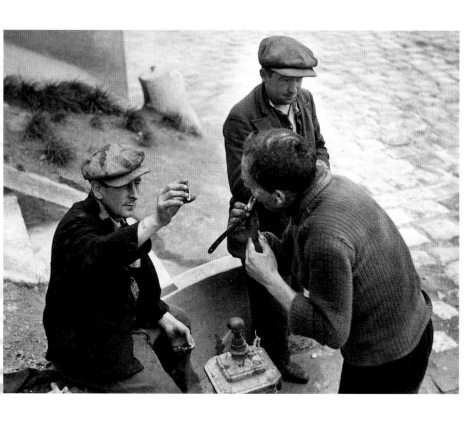

Touraine, France, 1929–30. From the time he arrived in Paris, Kertész was fascinated by the Paris rooftops and by views of the city. Up until his death, he made repeated use of the high-angle perspective for its capacity to render space geometrically. He produced numerous reports from the French provinces such as Touraine, as well as Lyons, Savoy, Corsica, Brittany, the Basque country and Lorraine, for the journal *Art et Médecine*. His friendship with the painter József Czáky, the leading figure amongst the Hungarian artists living in Paris, and a witness at his wedding to Rogi André, undoubtedly helped him to assimilate the forms of Cubism.

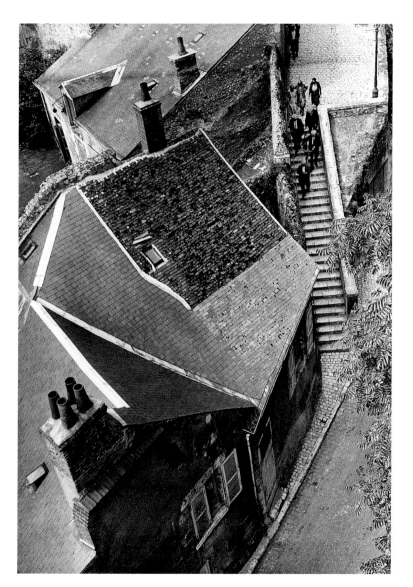

Paris, 1929–32. In 1929, Kertész was invited by *The Sphere* magazine to photograph the great academic institution, the Académie française. Fascinated by its memories, he recorded the ancient manuscripts, the paintings and sculptures of the old masters, and the library of the Institut de France. *The Sphere*, however, was more interested in the venerable institution's quaint, antiquated side, encapsulated by an academician caught dozing on a bench. The building's upper floors are occupied by the Institut de France, whose dome contains a clock that can be seen as far as the Pont des Arts. On the right bank of the Seine, the Louvre is visible.

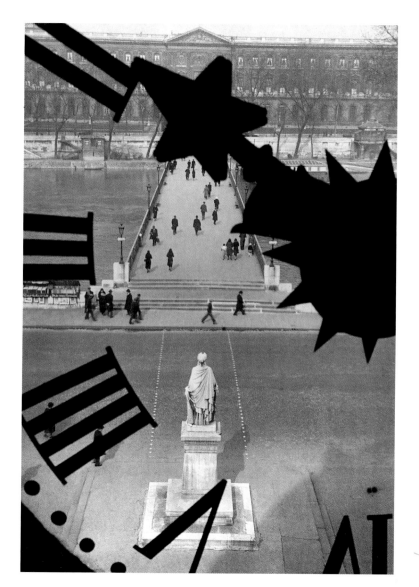

Self-portrait with Elisabeth, Paris, 1931. Taken in a Montparnasse café, probably the Dôme, this photograph is charged with a special emotion, since it records the couple's reunion. Separated from, but still married to, Rogi André, Kertész had resumed contact with Elisabeth, who visited him in Paris in 1931. They married in 1933, never to separate. This was Elisabeth's favourite photograph; she chose it to accompany her to the columbarium, where her ashes have rested since 1977.

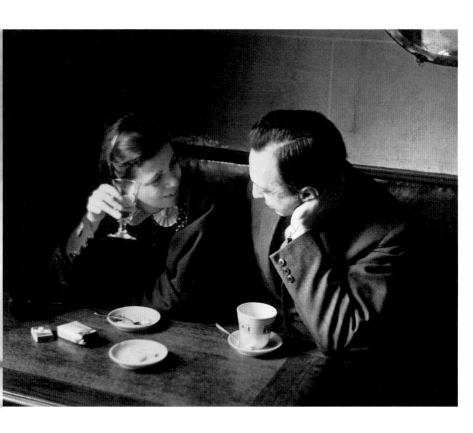

Elisabeth and Me, Paris, 1931. During this year of reunion with Elisabeth, Kertész wished to record the love that had united the couple since they first met in Budapest in 1919. He also wanted to put an enduring seal on their relationship by assuring Elisabeth of his loyalty and everlasting protection. His marriage to Rogi André had been a mere interlude, and Kertész subsequently acted as if it had never happened. It was not until forty years later that he produced this severely cropped version from the original shot, which shows a full view of the couple seated on the edge of a bed.

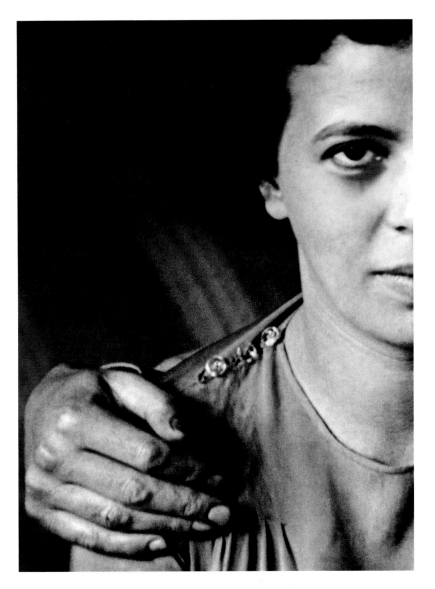

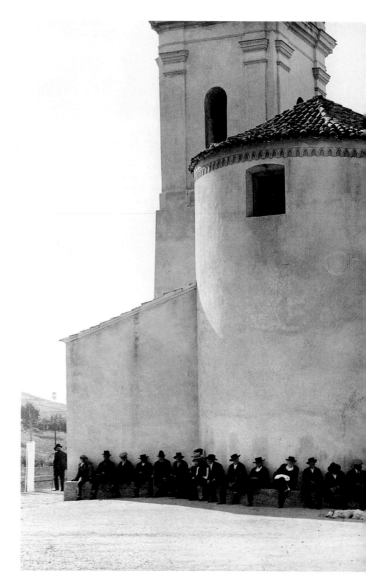

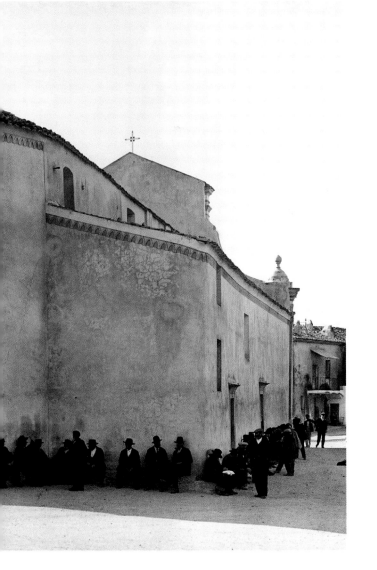

(previous page) Church in Piana, Corsica, 1933. In the summer of 1933, Kertész was sent to Corsica by Dr Debat, editor of the journal *Art et Médecine*. This monthly, devoted to leisure pursuits, was distributed free to doctors, and always included an article on one of the French provinces. Kertész made a lengthy tour of Corsica, spending time especially in Ajaccio, Bonifacio, Calvi, Cargèse, L'Île-Rousse and Porto. This picture was taken at high noon in Piana, in the northwest of the island. When Kertész saw the church in 1933, it was suffused with a pale pink from the colour of the rocks of the adjoining inlets. The low shot using a wide-angle lens spectacularly emphasizes the building's dimensions.

Paris, 1933. This picture superimposes two opposed ways of seeing: the Constructivist approach, and the aesthetics of the picture postcard. Constructivism made use of the new viewpoints afforded by modern cities. High- and low-angle shots and optical distortions were fully exploited to display the beauty of industry and the modern city. Other photographers who took the same subject, such as François Kollar, produced even more graphic compositions. In this picture, the verticality of the Eiffel Tower, positioned dead centre, is, as it were, crossed out by the horizontal line of the elevated railway. It is not clear whether it is intended as a manifesto or simply cocks a snook at conventionality.

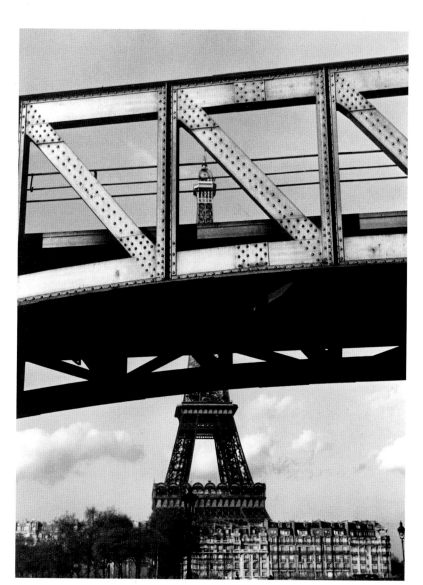

Distortion # 70, 1933. While living in the Hungarian countryside, in works such as *My Brother as a Scherzo* (1919), Kertész had learned to capture the beauty of a moving body. Sensitive to shimmering light, he had, in particular, produced the marvellous *Underwater Swimmer* (1917). In Paris, ten years later, he took portraits through a bull's-eye window. And in Luna Park, in 1929, he photographed himself and Carolo Rim, of *Vu*, in distorting mirrors. When Querelle, editor of the weekly *Le Sourire* (*The Smile*), asked him to produce nudes capable of 'renewing the genre', he was able to draw on these early works to create the 'Distortions'. Two Russian models, Najinskaya Verackhatz and Nadia Kasine, posed for him. Twelve photographs appeared in the issue of 2 March 1933.

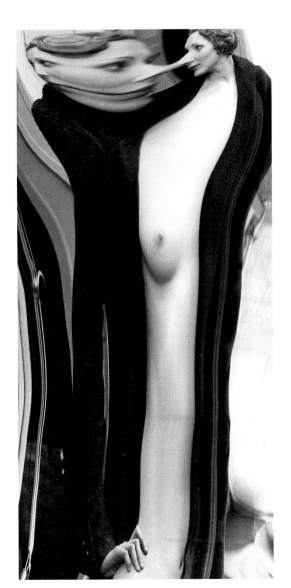

Distortion # 147, 1933. Fascinated by the first results, Kertész set to work again and (apparently in the course of nine sessions) produced two hundred 9 x 12 cm/3.5 x 4.75 in. glass plates using a Linhof camera. He remained true to direct shooting, not permitting himself any manipulation in the laboratory apart from cropping. Somewhere between caricature and eroticism, these deformed bodies seem to possess an elusive life of their own. But due to their joyous disorder, contracted or stretched to the limit, they were hardly shocking. It is the fusion of photographic tones and textures with the body's fleshy protuberances – prominent ribs, the curve of a breast, skin pores, pubic hair – that gives them their powerful attraction.

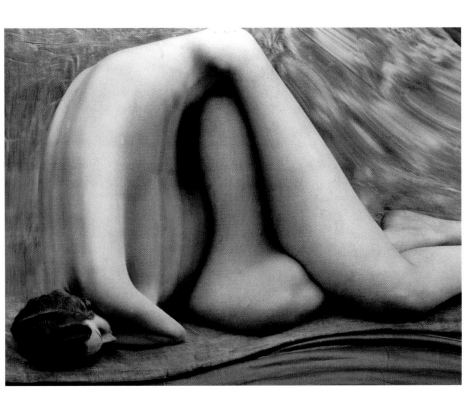

Metropolitan Museum, New York, 1936. Kertész's arrival in New York was a painful one. Erney Prince, General Manager of the Keystone agency, had brought him to the United States to take photographs in the style of *Harper's Bazaar*'s two star photographers, George Hoyningen-Huene and Horst. But Kertész's preferred territory remained the streets. Despite the threat of legal proceedings, he broke his contract with Keystone prematurely. At the same time, Beaumont Newhall, Director of the Museum of Modern Art's photography department, fearful of being accused of disseminating pornography, demanded that two 'Distortions' be cropped. Kertész retained bitter memories of this act of censorship.

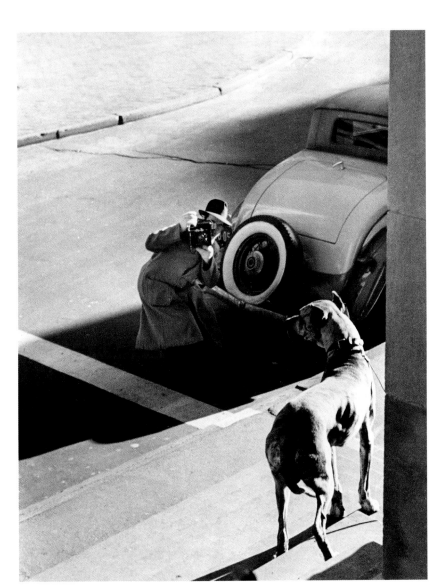

Lost Cloud, New York, 1937. It was unusual for Kertész to give his works proper titles such as this, as opposed to captions used for filing purposes (date, place, names of individuals, etc.). The adjective 'lost' endows the cloud with a personal, emotional dimension. The picture can be seen as an allegory of Kertesz's own displacement – far from the artistic fraternity of Montparnasse, poorly used professionally, and cut off from his roots.

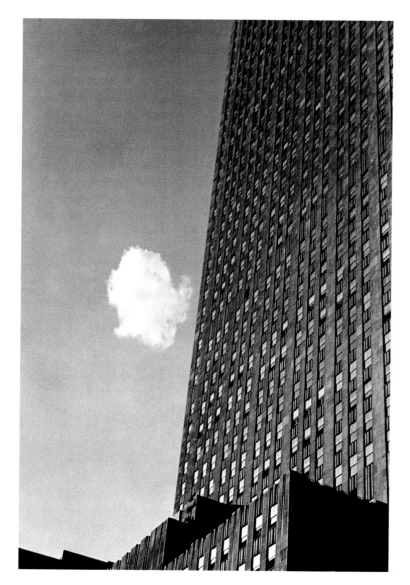

In Front of Rockefeller Center, New York, 1937. During his first two decades in New York, Kertész walked the streets, just as he had done in Paris. He had always been fond of photographing animals. In Hungary he took pictures of chicks, goats, sheep and horses. In France he published a small book on farm animals, *Nos amis les bêtes* (*Our Friends the Animals*, 1933). Even if he was implying in this work the dehumanizing monumentality of New York, he did not carry it into the realm of genuine social criticism.

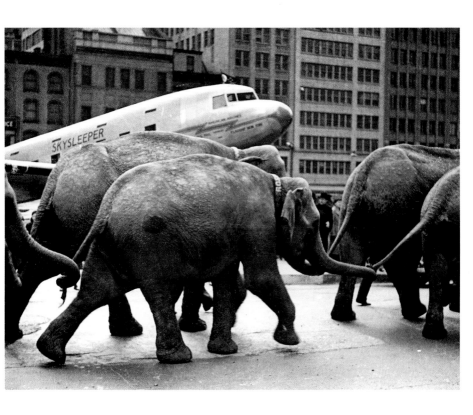

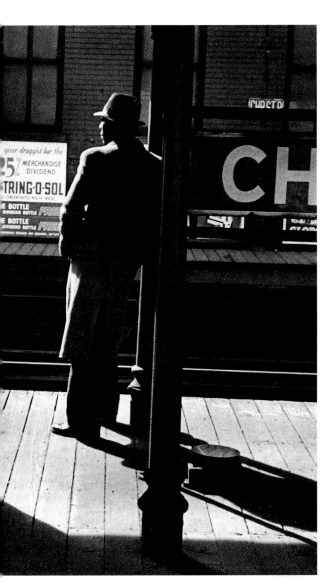

(previous page) New York, 1937. Having extracted himself from the Keystone agency, Kertész hoped that he would be able to continue taking the same sort of photographs as he had in Paris. However, it was not only his surroundings that were different, but the channels through which photographic work was distributed. Magazines such as *Life*, launched by Henry Luce in 1936, demanded harder-hitting pictures, with increasingly voyeuristic appeal. Pictures such as this show how Kertész remained a solitary passer-by, observing his fellow beings with tenderness and compassion.

Poughkeepsie, New York, 1937. This photograph is symptomatic of Kertész's method during his New York years. His eye first perceived an overall composition, which gave structure to the picture. Then he waited for the mobile elements to come into the frame, passing each other or lingering there. While the scene concentrates on formal elements – extending from close up to far away – it also displays a tangible sense of suspended time – an interval fraught with intense expectation.

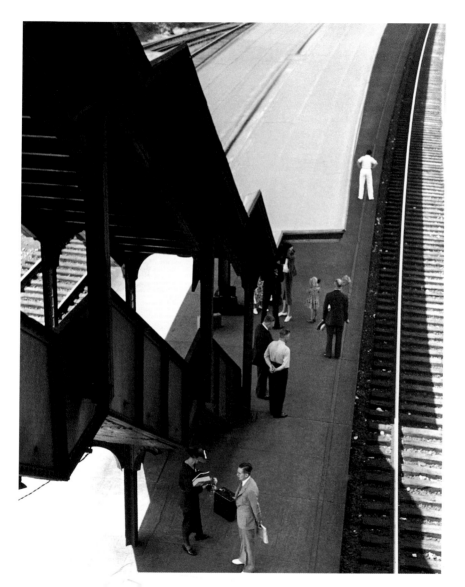

Homing Ship, Central Park, New York, 1944. During the period between April 1941 and June 1944, Kertész, as a citizen of a country at war with the United States, was classified by law as an 'enemy alien', and was unable to publish in American periodicals. Though the title of this picture might suggest a desire to return to Europe, he probably never seriously considered going back. When he took out American citizenship at the end of the war, he was certain that he wanted to continue living in his second adopted country. But as a photographer deprived of work in the most difficult of circumstances, who longed to recover his freedom and the joy of taking photographs, he may well have identified with this image of a boat, displaced from its natural element.

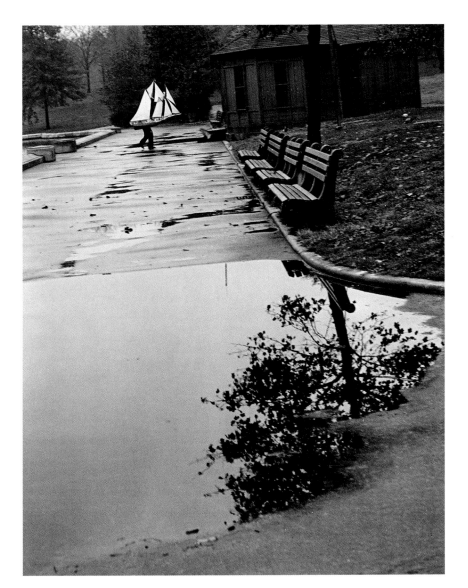

New York, 1946. Even in his earliest photographs, Kertész demonstrated an understanding of the creative use of cropping. On his contact sheets, he made careful note of his selections and the adjustments necessary to improve the compositions. In this photograph, he used the emptiness of the sky as a basic formal feature. Each element is positioned so as to contribute to the tension of a space that, at its centre, opens onto a void. Here, Kertész simultaneously expresses emptiness and the power of looking.

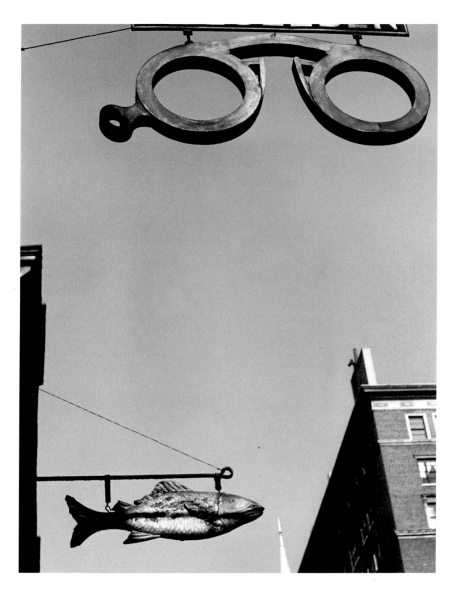

Washington Square, New York, 1954. In 1952 Kertész and Elisabeth moved into an apartment overlooking Washington Square. From the balcony, he took thousands of high-angle shots of the square's gardens. Aged nearly sixty, he now found the streets too vast, fast-moving and noisy. By moving to an elevated vantage point, Kertész was also stepping back. Throughout the changing seasons, he tirelessly observed children playing, the paths traced by anonymous silhouettes, or as night fell and the park emptied, the square left solely to the trees and the birds.

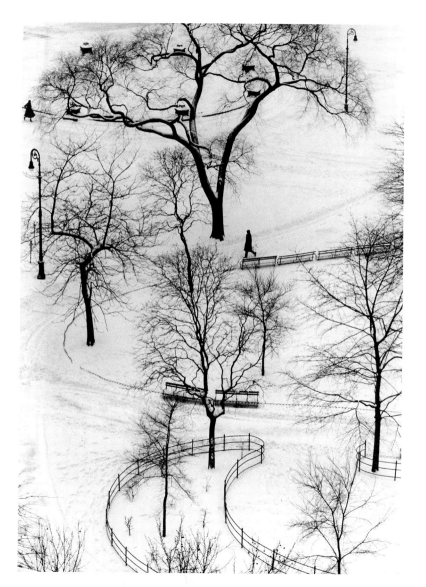

Broken Bench, New York, 1962. Kertész took this photograph when visiting a friend in hospital. She can be seen sitting beside Elisabeth on the bench in the background. The man in the foreground is Kertész's friend and compatriot, Frank Tamàs, whom he had met in Paris and who was Elisabeth's partner in her cosmetic business, Cosmia Laboratory. The triangular structure of the photograph hints at the existence of some hidden story, whose enigma we will never solve.

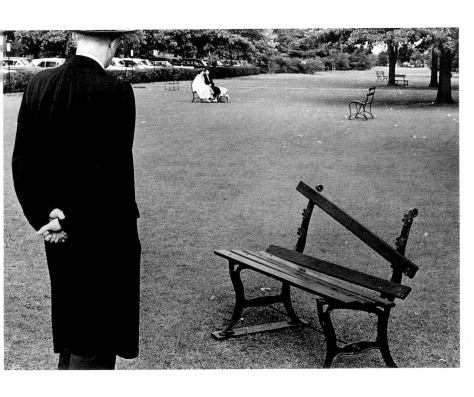

University of Long Island, New York, 1962. Kertész regarded the faculty of sight as a priceless gift, and saw nature as 'the most beautiful thing in the world'. He tried to reach that beauty through photography, but commented, 'The best photographs are those I never took.' In contrasting the tree's organic structure – treated as a shadowgraph, like the clock in Paris, 1929–32 – with the implacable brick façade of the University, Kertész was not making an indictment of the modern city. He was simply acknowledging the right of forms to express themselves through their own qualities.

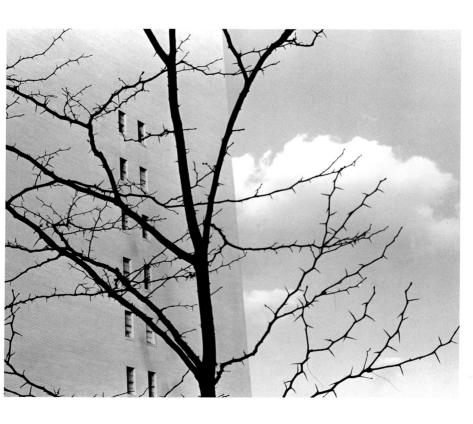

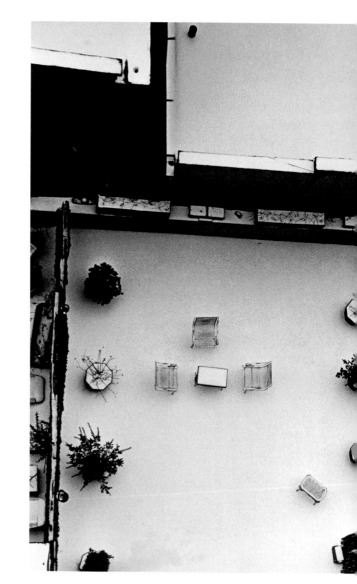

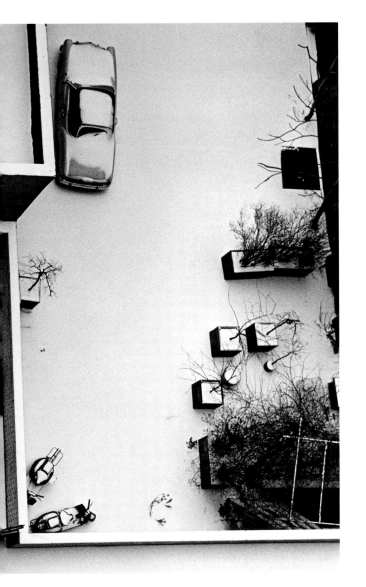

(previous page) MacDougal Alley, New York, 1965. From the 1960s onwards Washington Square and MacDougal Alley were Kertész's favourite subjects Living on the twelfth floor, he had a clear view of them, and could take advantage of the vertical perspective. At that height, obliteration of the distances between levels enabled him to compose perfectly balanced geometric pictures This was taken early one morning, before any pedestrians had made their tracks in the snow.

New York, 1965. Kertész took several photographs of this shop sign before the policeman came out of the neighbouring building. It was a perfect moment, for the strength of the picture, which is Surrealist in spirit, hangs on the abrupt change of scale between the rose and the figure of the man. 'Of course a picture can lie,' commented Kertész, 'but only if you yourself are not honest or if you don't have enough control over your subject.'

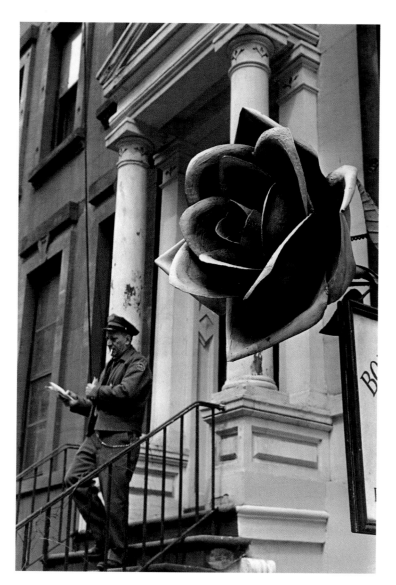

Martinique, 1 January 1972. On holiday in the Antilles with Elisabeth, Kertész took photographs from the balcony of their hotel. The occupant of the adjoining room, an enigmatic figure reduced to a silhouette, seems to be contemplating the sea. Consciously or otherwise, Kertész is borrowing one of the favourite themes of Romantic painting. For the Romantics, the sea was a mirror of inner emotions. One can make a conceptual analogy between this picture and those of Victor Hugo, in exile on Jersey and Guernsey, photographed on the rocks by the sea, his gaze fixed on the horizon.

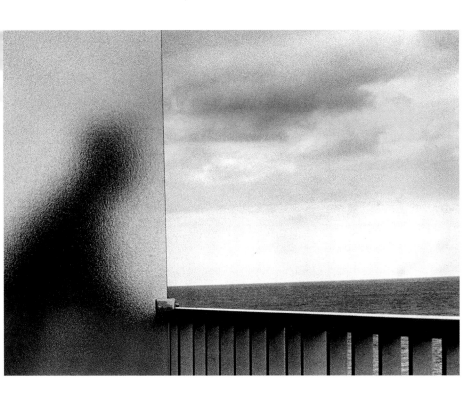

New York, 1973. Unlike his contemporary Berenice Abbott whose photographs celebrated New York's architecture, Kertész was divided between finding it fascinating and oppressive. Architecture, as such, interested him little. What did interest him was the way in which city dwellers adapted to the gigantic scale of the steel, concrete and glass buildings. If Budapest was the city of his family nest, and Paris the city of artistic fraternity, New York was the city of countless little solitudes.

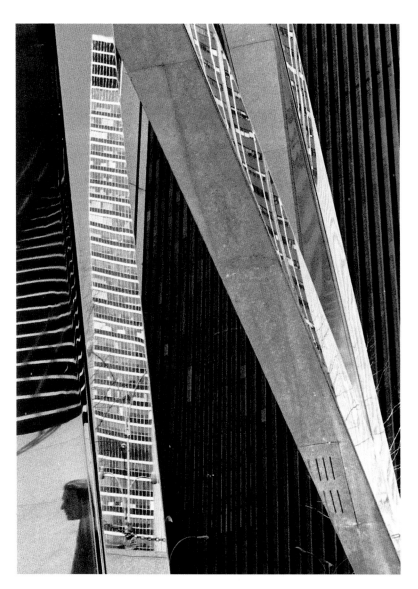

New York, 1975. When taking high-angle shots, Kertész frequently used a zoom lens. In this way, he compensated for his unchanging vantage point through the possibility of surveying a great variety of visual fields. Even if, at the age of eighty-one, the streets were now out of bounds to Kertész, he never completely abandoned the subjects dear to his heart. These photographs echo the series 'As from my window I sometimes glance' (1957–58) taken by voluntary recluse W. Eugene Smith from the window of his Sixth Avenue apartment.

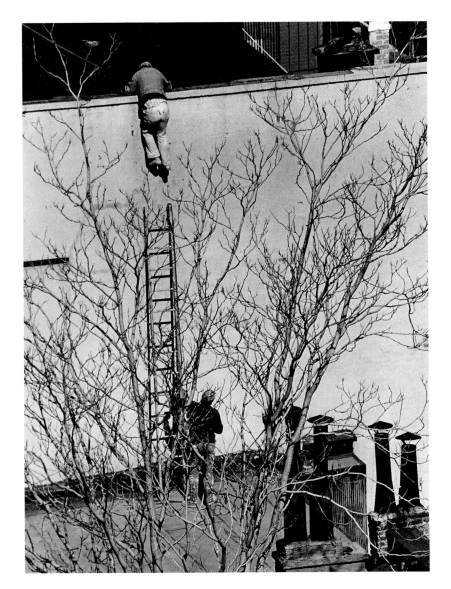

New York, 1979. In 1981 the book *From my Window* presented Kertész's Polaroid colour work. This photograph continues that series, which skilfully melded still life with urban landscape. According to Kertész, the glass bust represents Elisabeth, who had died of cancer in 1977. Kertész set up many scenes with other figurines, their fluid, luminous forms overlapping one another.

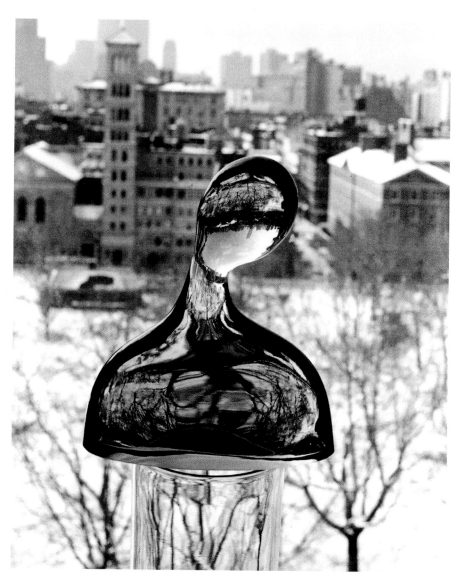

Paris, 1982. This fortuitous encounter between a swan and a lamp-post was captured when the Seine overflowed its banks. Kertész's art, however, lay in his ability to transform what could have been a trivial image into flowing calligraphy. 'We don't really know how beautiful nature really is,' he commented. 'We can only guess.'

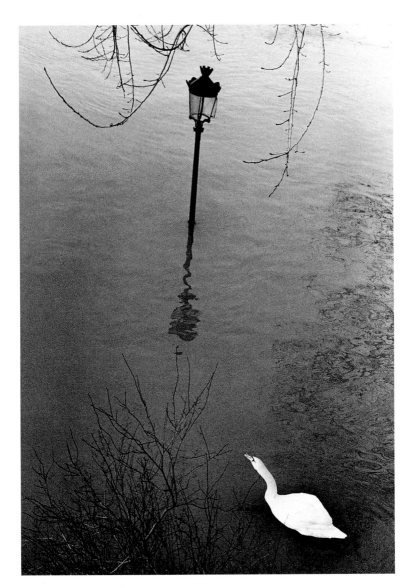

Notre Dame de Paris, 1983. When he returned to Paris to visit friends and attend the opening of an exhibition, Kertész liked to stroll along the banks of the Seine, remembering the past. This part of Paris, near Notre Dame, had changed little since his departure in 1936. Kertész cultivated this nostalgia, for the motivating force of his work was the attempt to capture the passing moment, while knowing that as soon as one tries to seize it, it is gone.

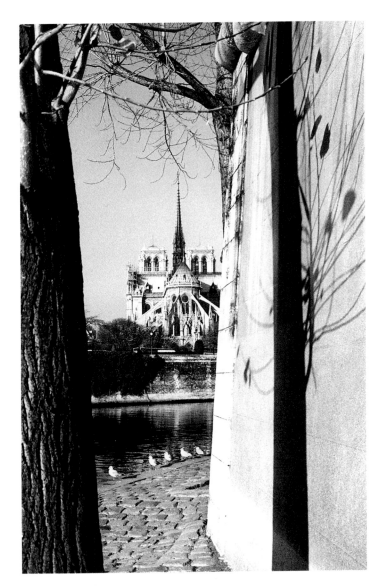

1894 Born 2 July into a Jewish family in Budapest.

1909 His father, Lipót, dies of tuberculosis.

1912 Obtains a job on the Stock Exchange. Buys his first camera.

1914 Recruited into Austro-Hungarian army, volunteers for the front.

1915 Wounded in battle.

1918–1925 Returns to his job on Stock Exchange but continues to photograph.

1925 Arrives in Paris in September. Frequents avant-garde literary and artistic circles and the Hungarian community Meeting with Brassaï. Makes portraits of Mondrian.

1926–1935 Freelance photographer for French, German and English magazines.

1927 First exhibition at avant-garde gallery Au Sacre du Printemps, Paris.

1928 Marries Rózsa Klein (Rogi André). They separate two years later.

1928–1935 One of the main contributors to magazine *Vu*, edited by Lucien Vogel.

1929 Takes part in 'Film und Foto' exhibition, Stuttgart.

1930–1936 Contributes to *Art et Médecine* journal edited by Dr Debat.

1931 Exhibition at Julien Levy Gallery, New York.

1933 Returns to Budapest for his mother's funeral. Publishes his first book, *Enfants* (*Children*). Produces series 'Distortions' for the magazine *Le Sourire*. Marries Elisabeth Sali (Salamon).

1934 Publishes *Paris vu par André Kertész* (*Paris as Seen by André Kertész*), with text by Pierre MacOrlan.

1936 Leaves for New York to fulfil a contract with Keystone agency, which he breaks the following year.

1937 First solo exhibition in New York, at the PM Gallery. Freelance photographer for the American press.

1941 Legally classified an 'enemy alien' because of his nationality, he is forbidden to publish for several years.

1944 Obtains American nationality.

1945 Publishes *Day of Paris*, a project conceived by Alexey Brodovitch.

1946 First solo exhibition at American museum, the Art Institute of Chicago. Signs an exclusive contract with Condé Nast. Produces photographs of interior decoration for *House and Garden*.

1952 Moves to 2 Fifth Avenue and starts a series on Washington Square.

1962 Ends contract with Condé Nast and devotes himself to his own work.

1963 Takes part in IVth Mostra, Venice. Solo exhibition at National Library, Paris. Recovers negatives from his time in Hungary and France, hidden during war in château in south of France. His work begins to receive international recognition.

1964 Exhibition at Museum of Modern Art, New York, organized by John Szarkowski.

1975 Guest of honour at the International Festival of Photography, Arles, France.

1977 Elisabeth dies of cancer on 21 October.

1979–1981 Using Polaroid camera, makes series of still lifes in his apartment, later published as *From my Window*.

1982 Publishes *Hungarian Memories*.

1983 Awarded the Legion of Honour by French government.

1984 On 30 March, signs deed donating all negatives and correspondence to French state (Ministry of Culture). Makes a last trip to Budapest.

1985 Exhibition 'André Kertész, of Paris and New York', at the Art Institute of Chicago and the Metropolitan Museum of Art, New York. On 28 September, André Kertész dies in his New York home.

Photography is the visual medium of the modern world. As a means of recording, and as an art form in its own right, it pervades our lives and shapes our perceptions.

55 is a new series of beautifully produced, pocket-sized books that acknowledge and celebrate all styles and all aspects of photography.

Just as Penguin books found a new market for fiction in the 1930s, so, at the start of a new century, Phaidon **55**s, accessible to everyone, will reach a new, visually aware contemporary audience. Each volume of 128 pages focuses on the life's work of an individual master and contains an informative introduction and 55 key works accompanied by extended captions.

As part of an ongoing program, each **55** offers a story of modern life.

André Kertész (1894–1985), one of the pioneers of 'spontaneous' photography, was a highly original artist. Eschewing the dogmatic positions of schools and movements, he let himself be guided only by his intuition, drawing on his private life for inspiration. His quest for visual authenticity led to the invention of an innovative visual language.

Noël Bourcier is Artistic Director of the André Kertész Foundation in Paris. He has curated numerous exhibitions and written many books and articles on photography, including the monograph *Denise Colomb* (1992).

Phaidon Press Limited
Regent's Wharf
All Saints Street
London N1 9PA

Phaidon Press Inc.
180 Varick Street
New York NY 10014

www.phaidon.com

First published 2001
©2001 Phaidon Press Limited
Translation from French:
Vincent Homolka

ISBN 0 7148 4040 8

Designed by Julia Hasting
Printed in Hong Kong

The photographs of André Kertész are preserved and promoted by the Association Patrimoine Photographique in Paris – photographs by André Kertesz ©Ministère de la Culture – France.